AMH Art Dragon Coloring Book

© 2016 Aubrianna Marie Harris
All Rights Reserved

ISBN-13:
978-1534696440
ISBN-10:
153469644X

About the author

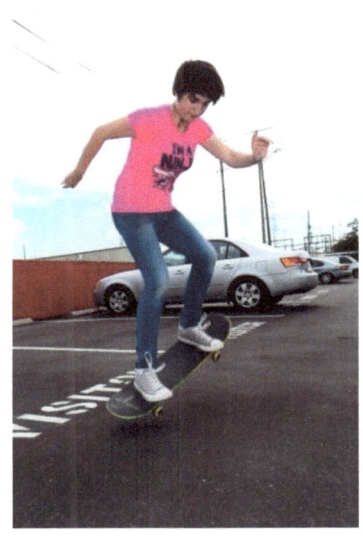

Aubrianna Harris is a 15 year old professional artist. This is her first series of coloring books. She attends high school online so that she is able to produce more art and keep her career going strong. Aubri also skateboards and plays guitar, and hopes to attend college in the coming years to develop her skills and her business.

Acknowledgements

I would like to thank my parents and little sister for helping me to create this book. Also, special thanks to my dog, Yoda. He is a good boy, and a good model.

-Aubrianna

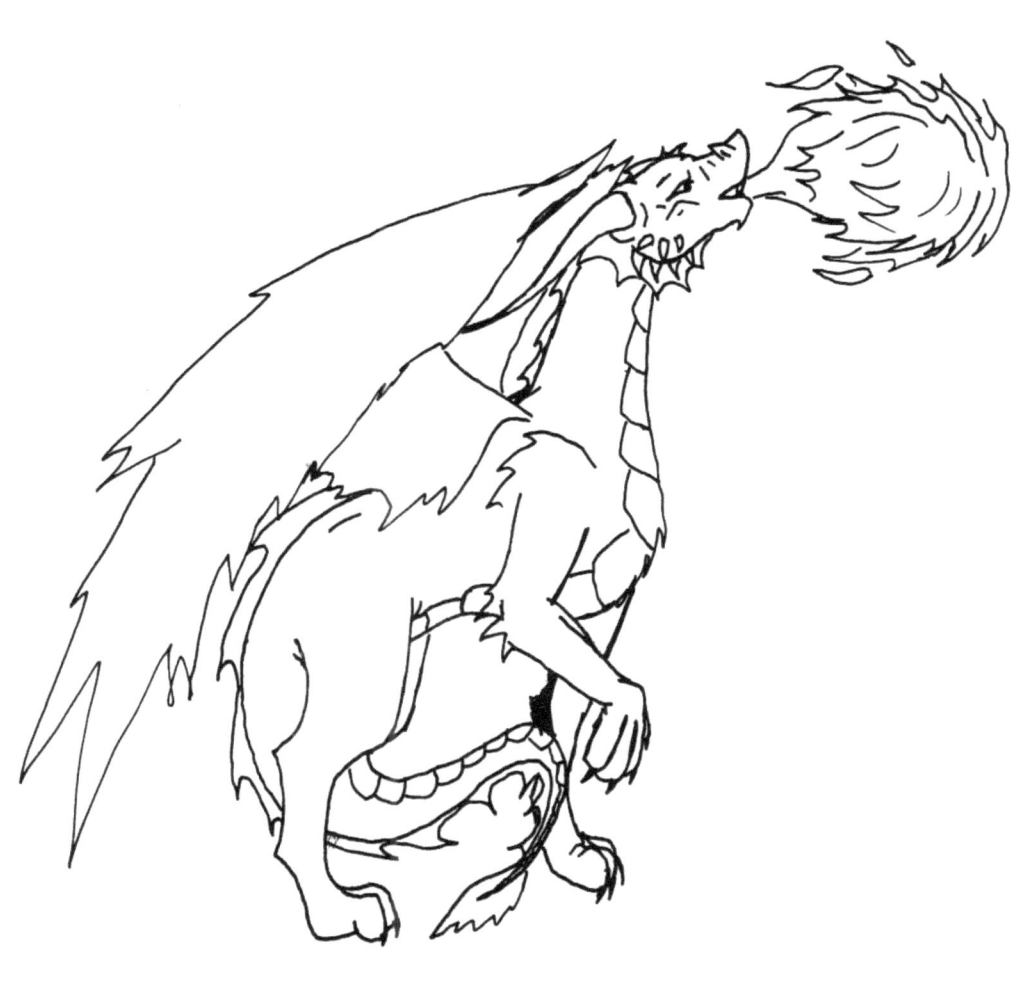

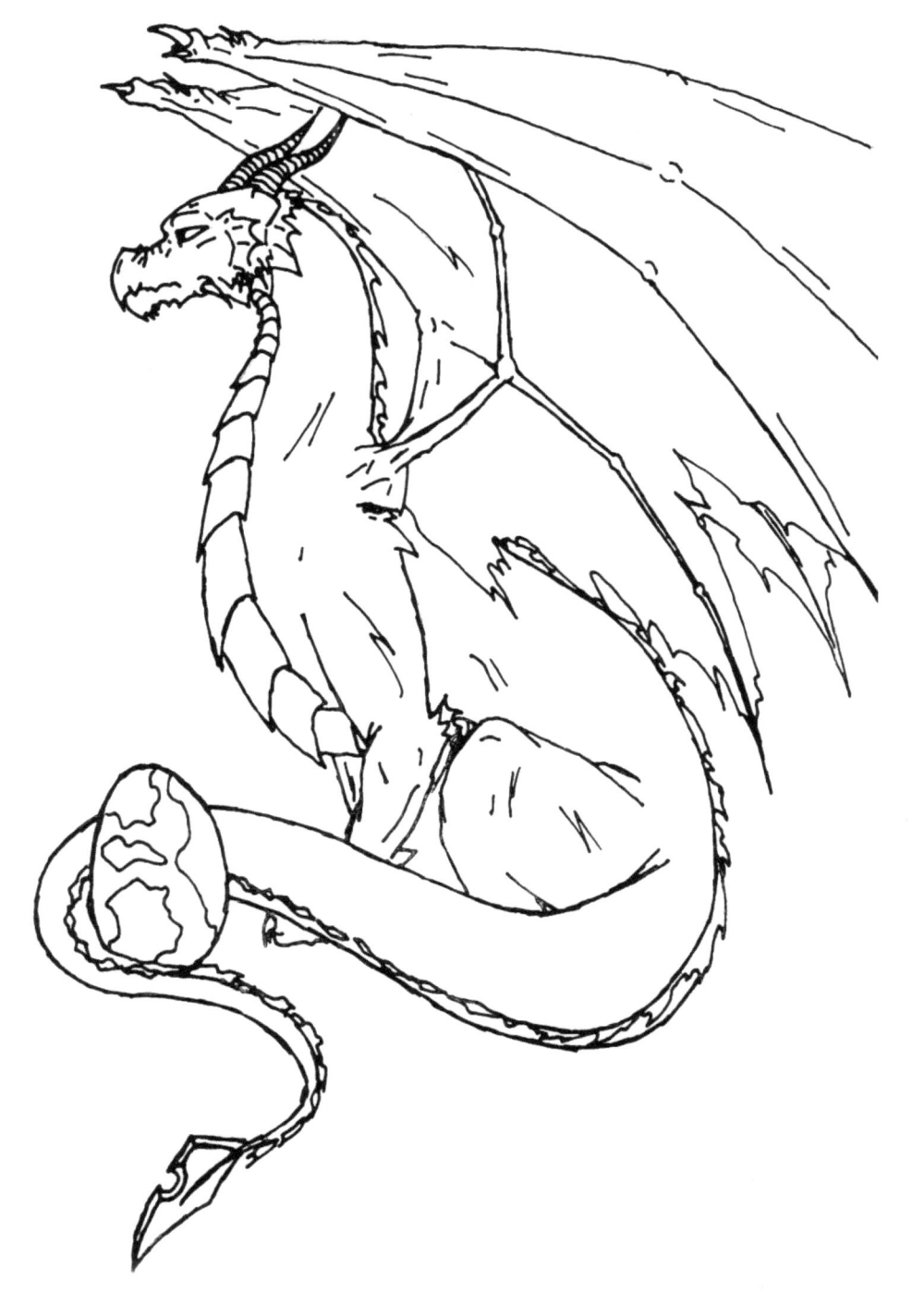

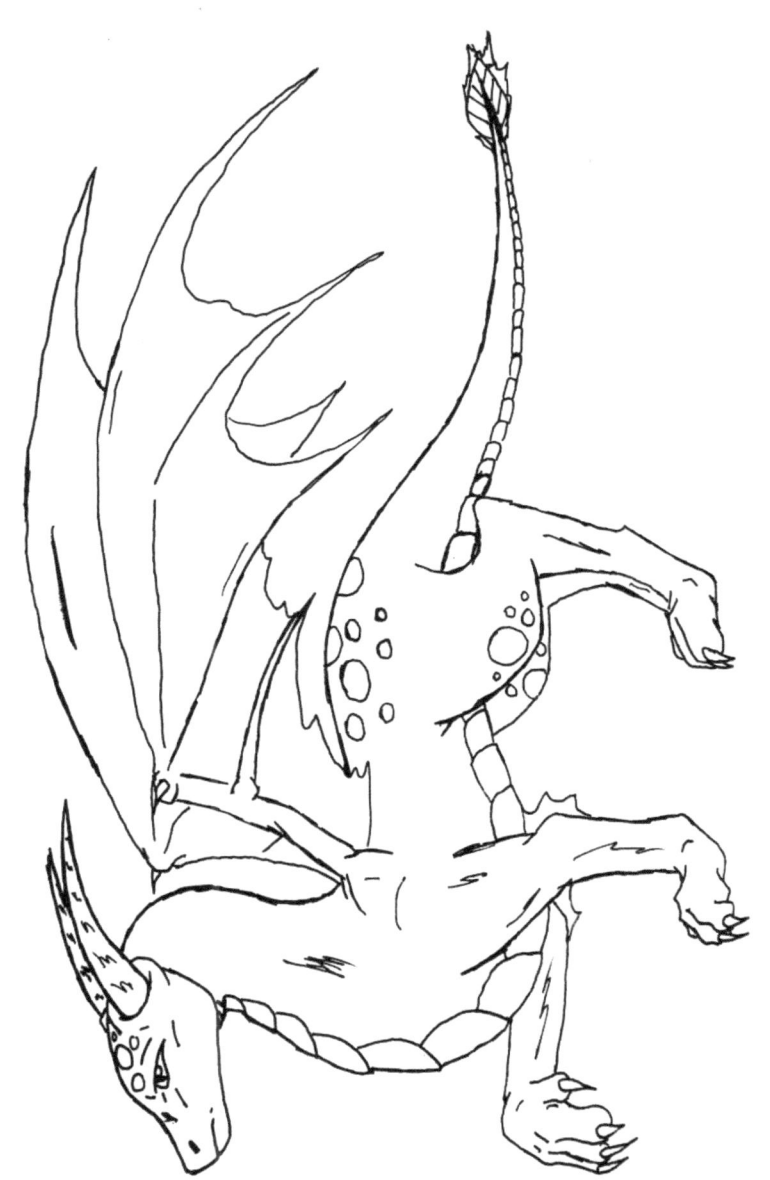

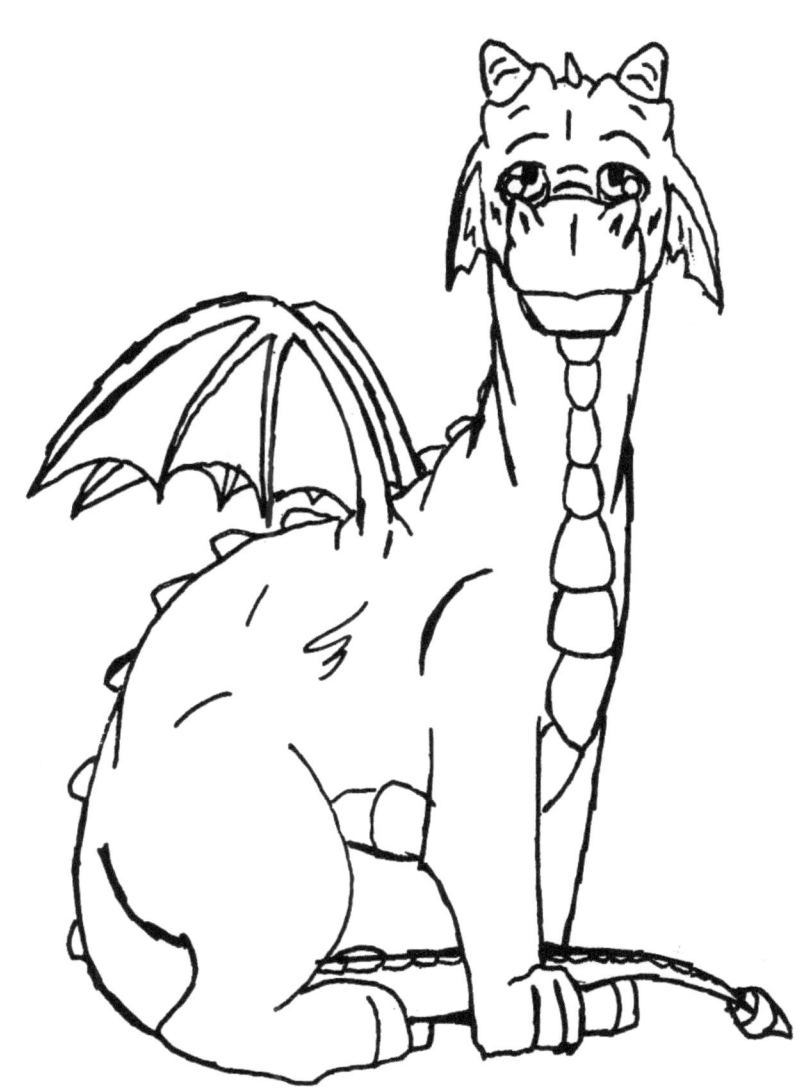

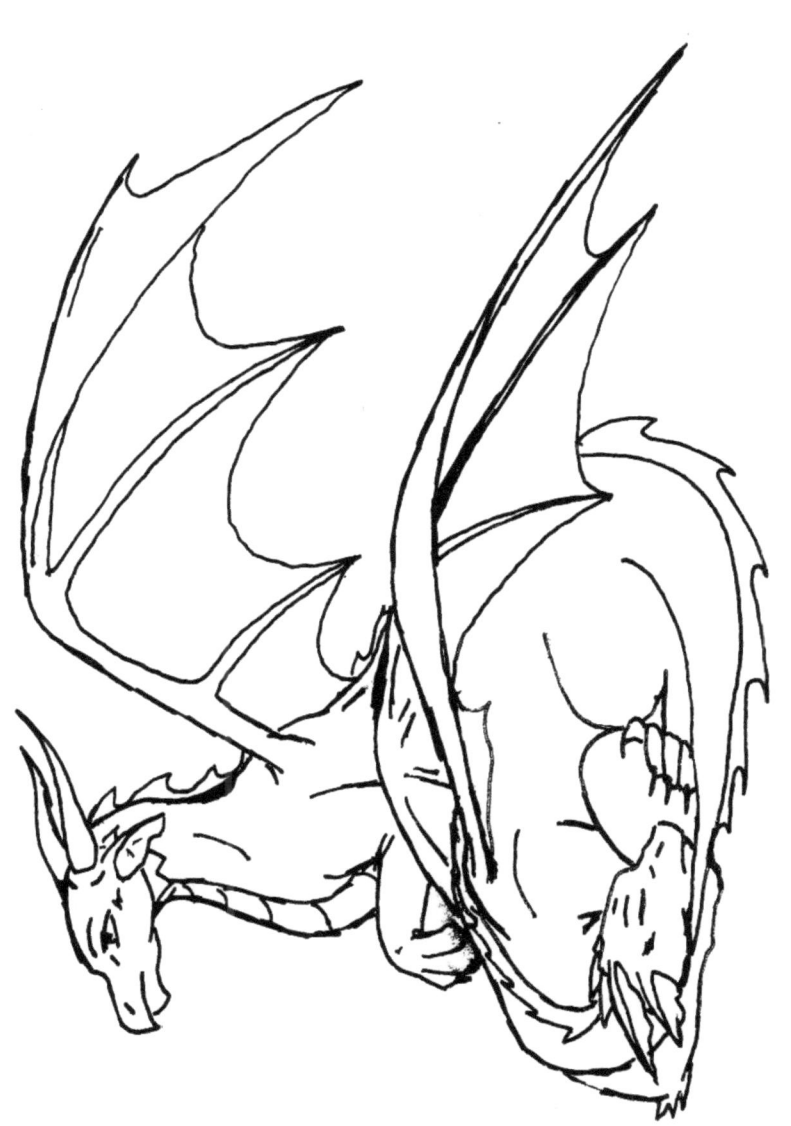

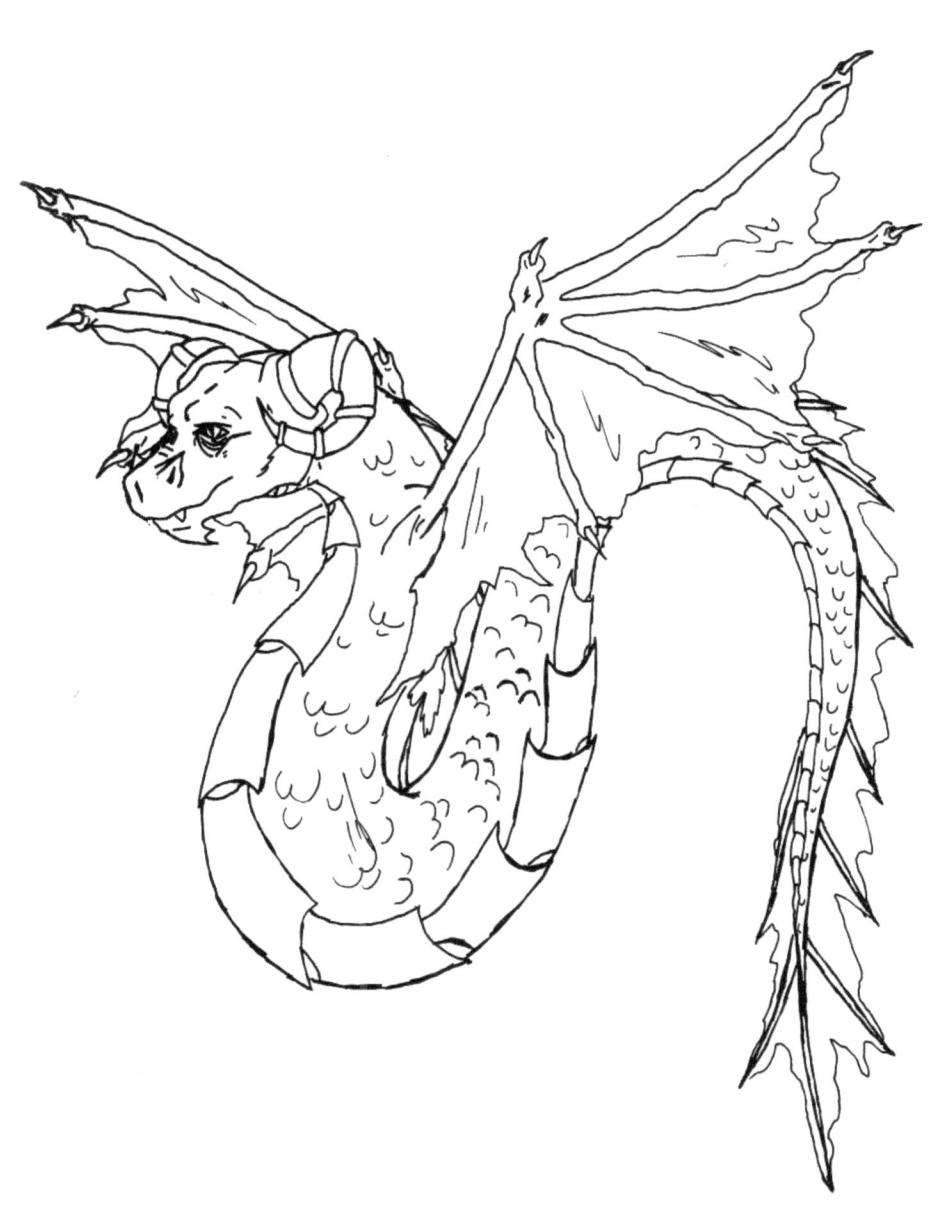

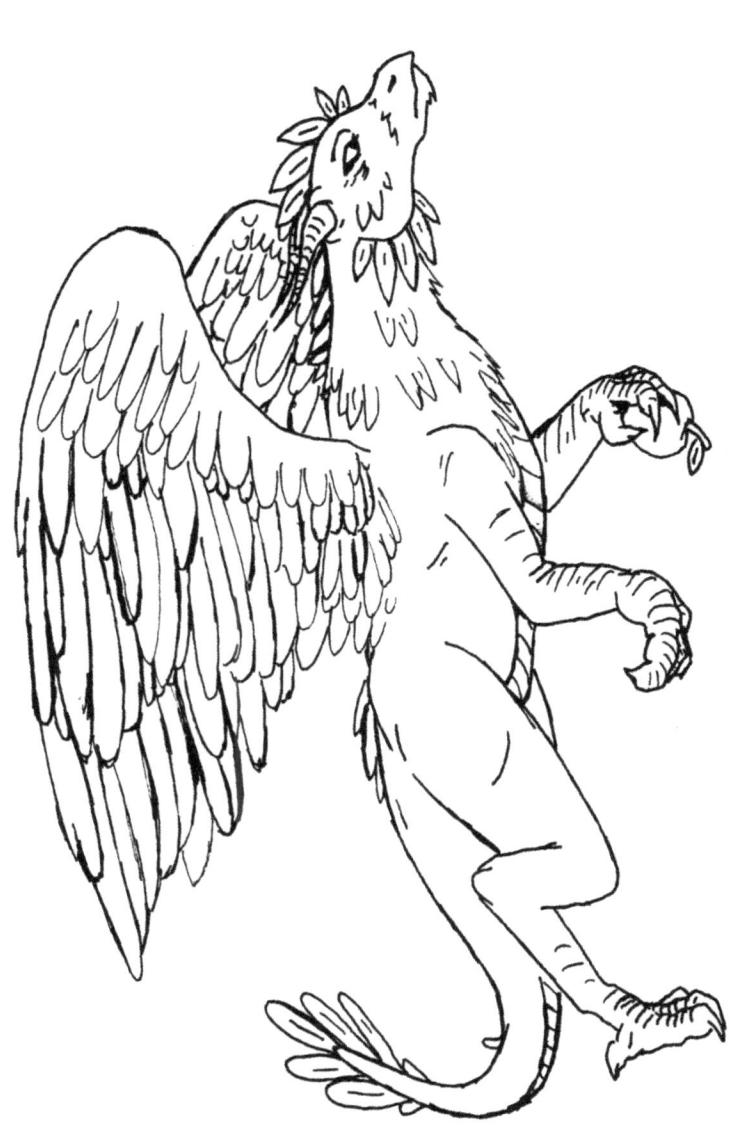

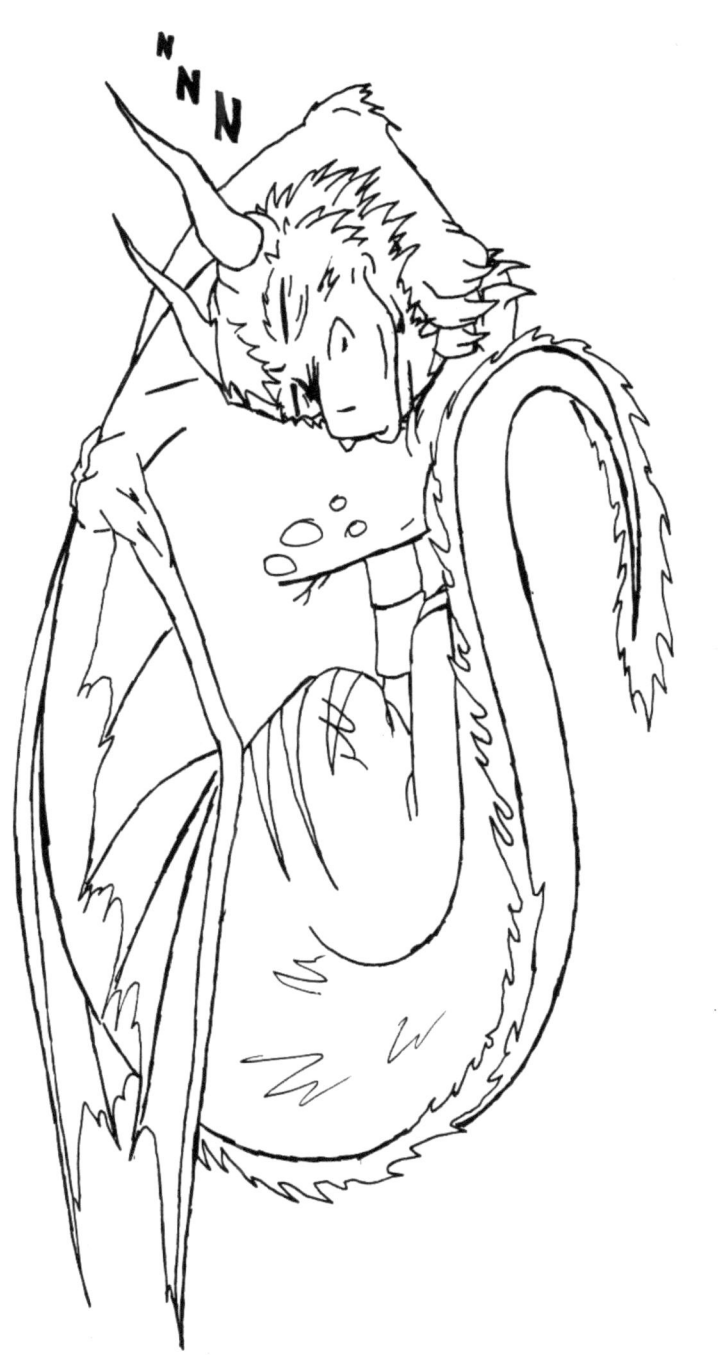

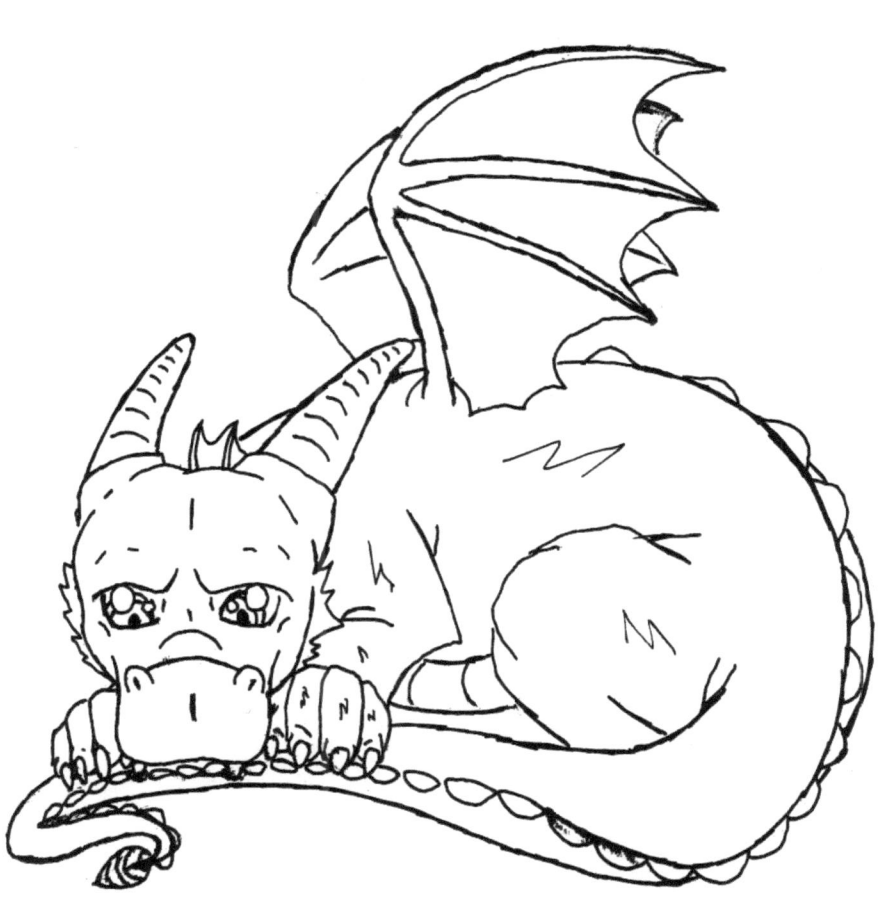

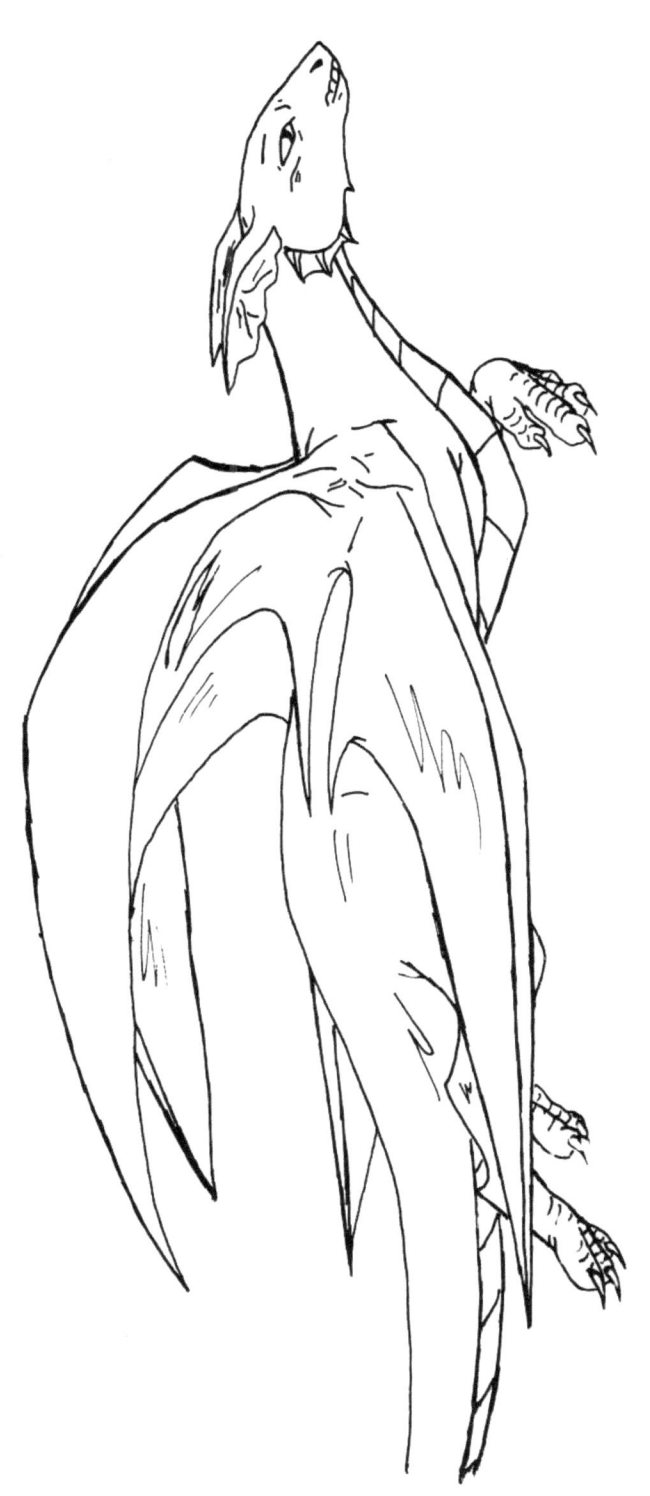

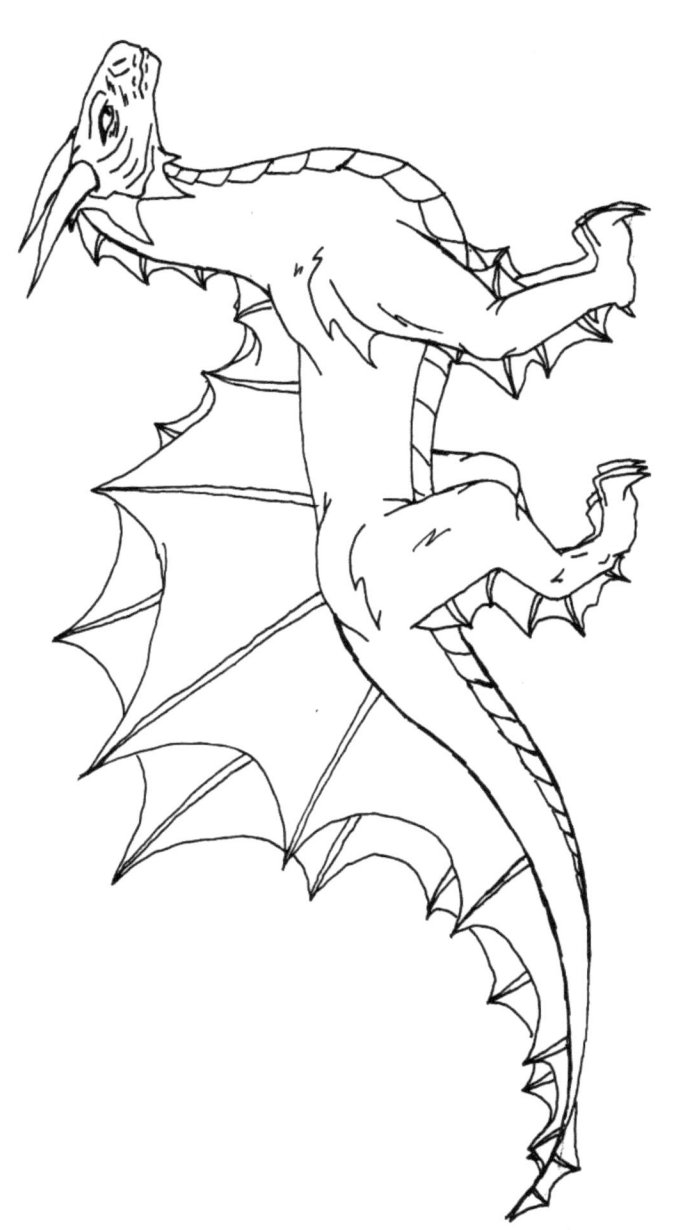

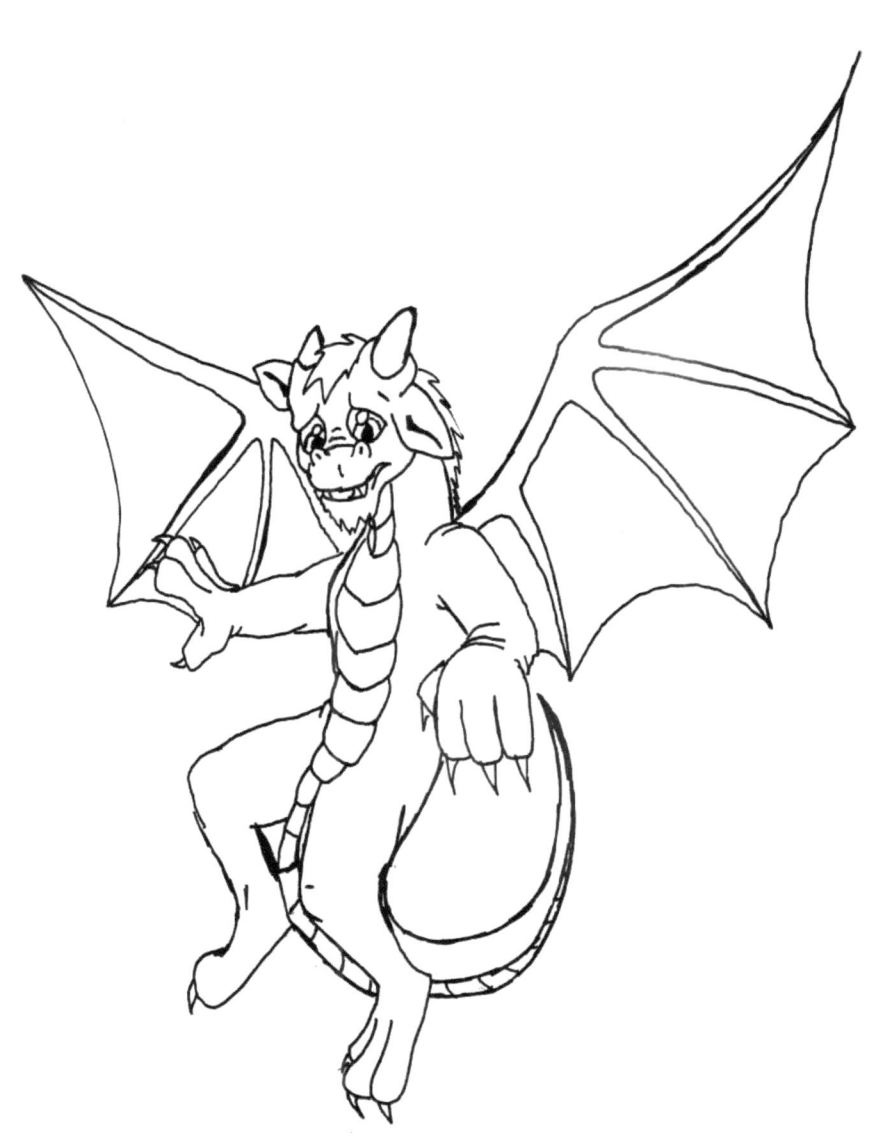

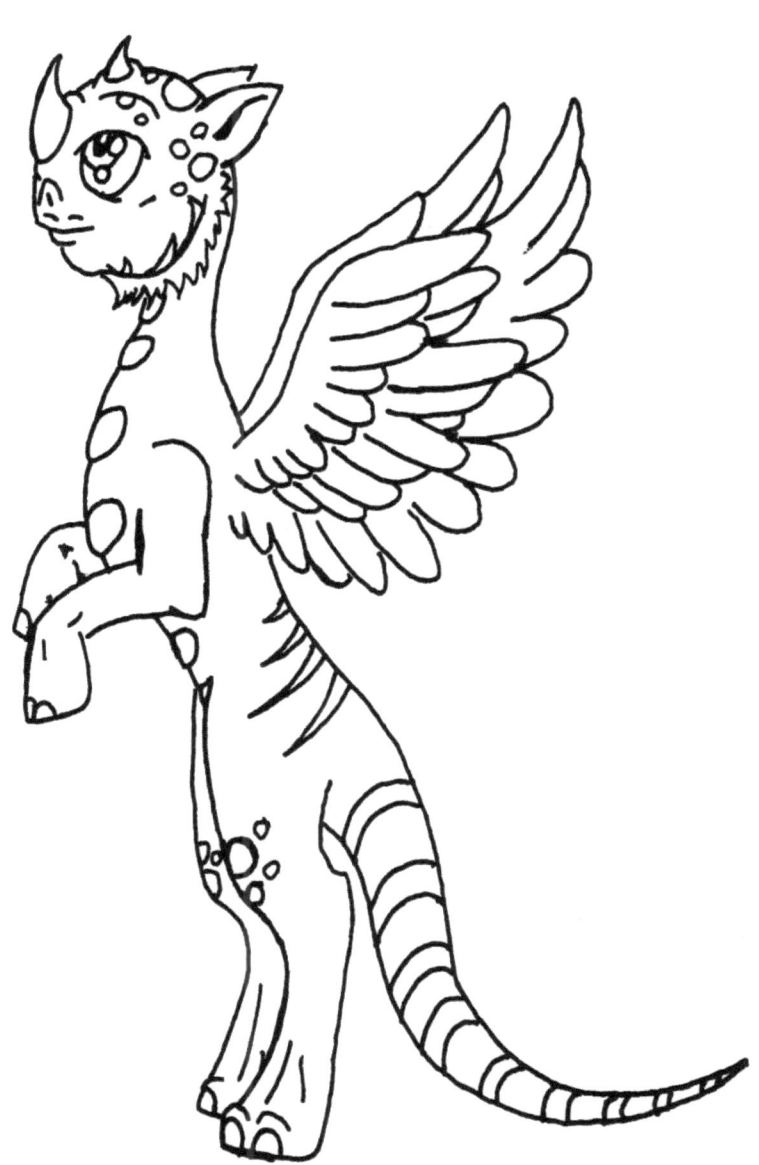

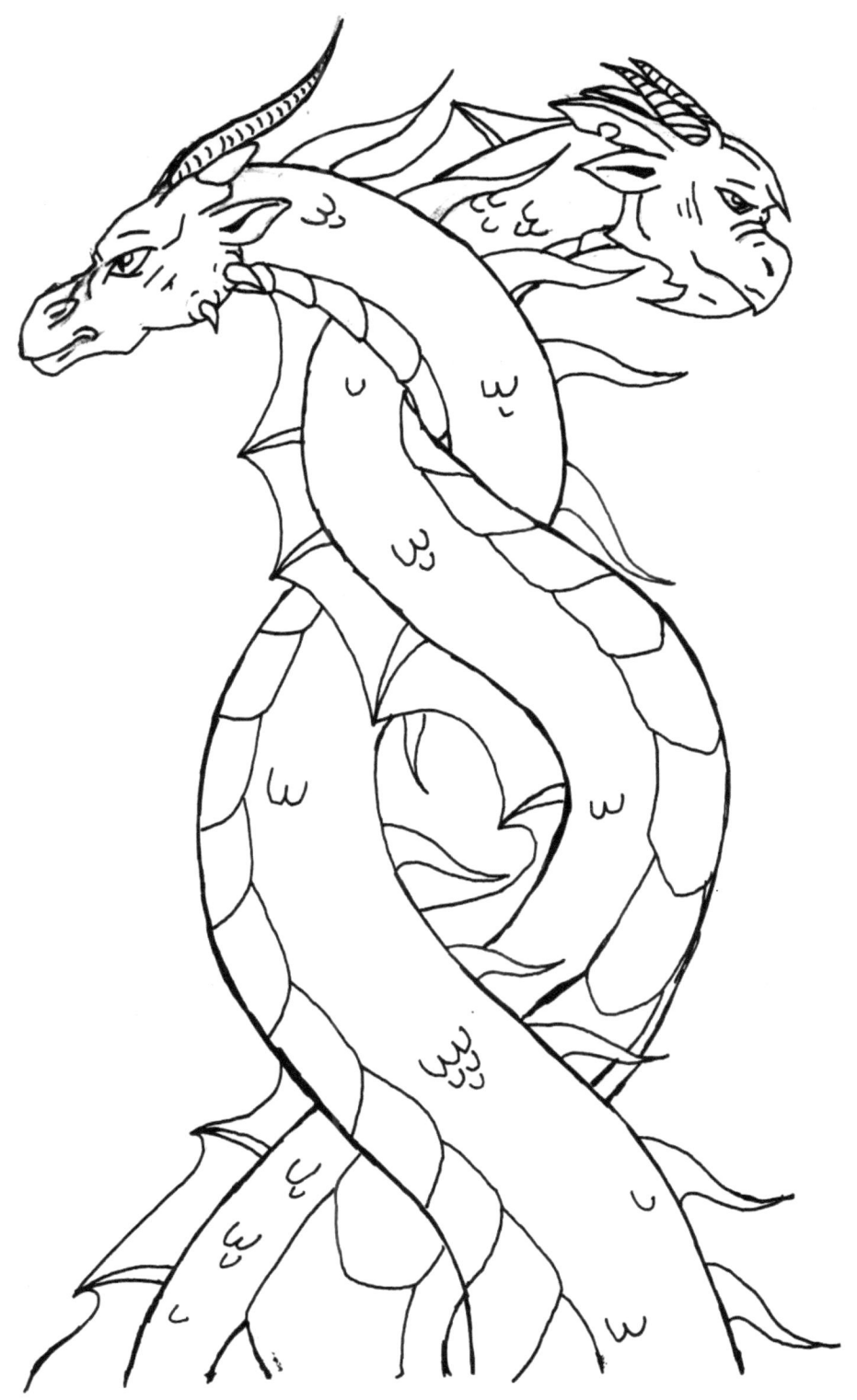

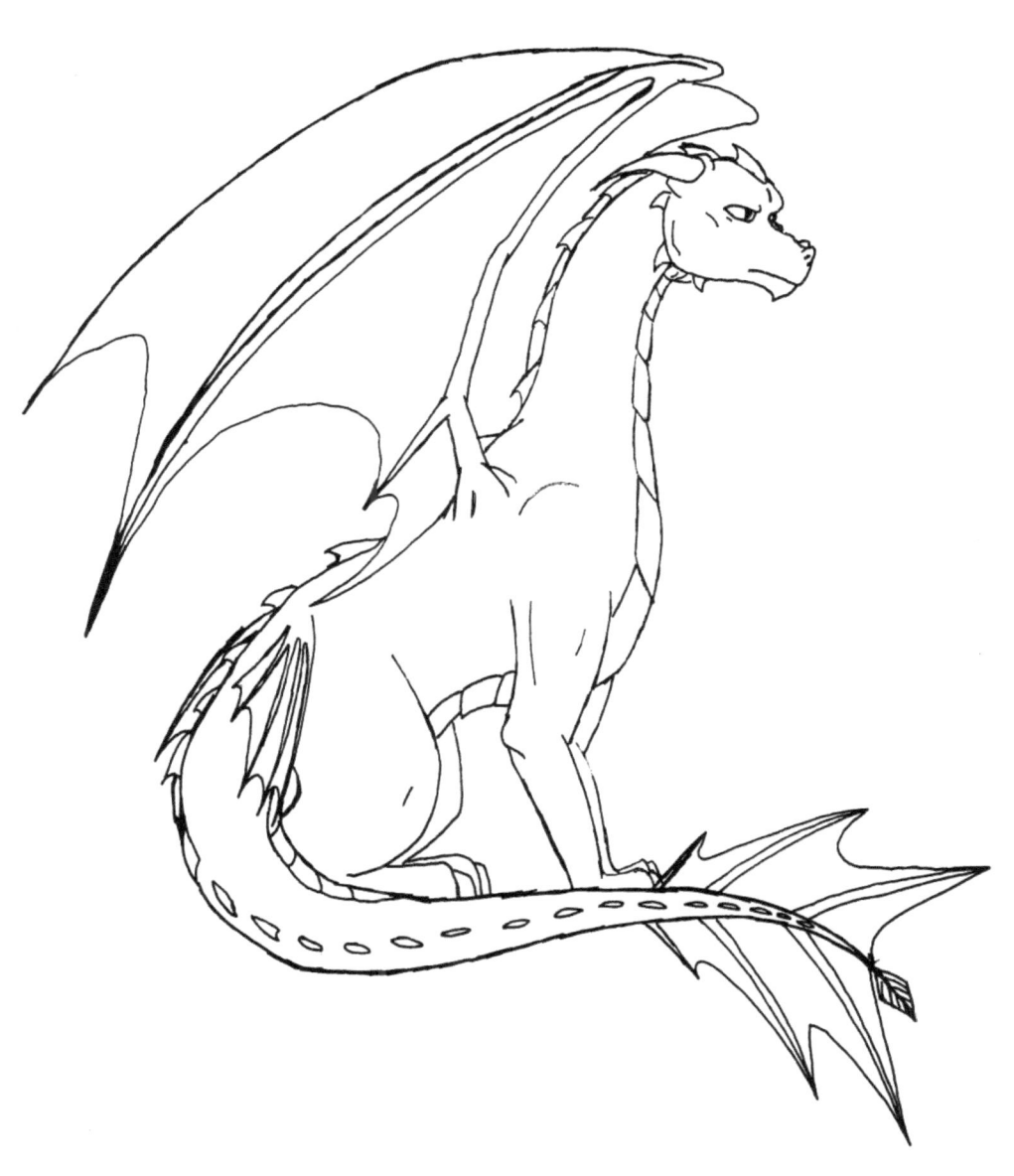

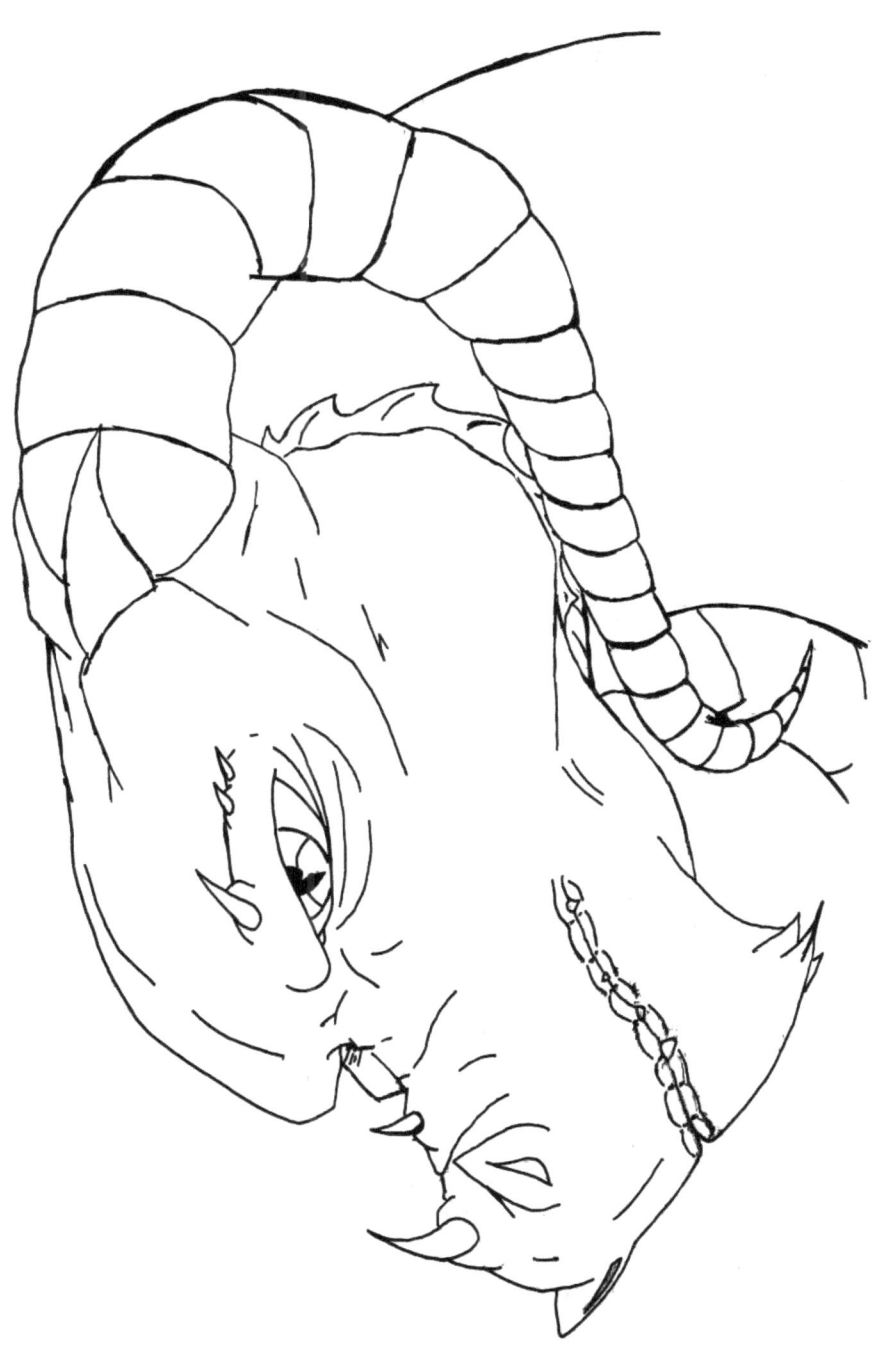

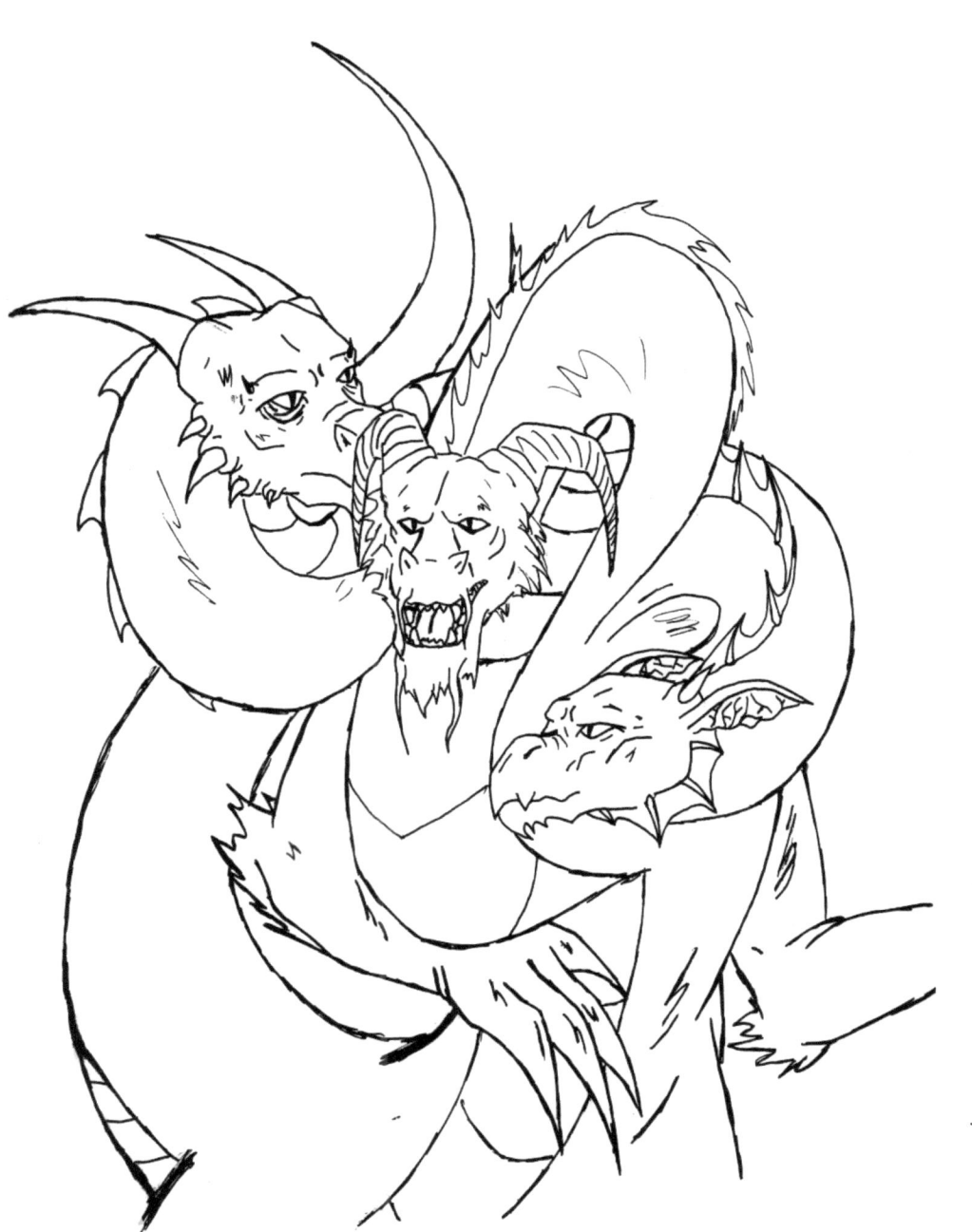

www.ingramcontent.com/pod-product-compliance
Lightning Source LLC
Chambersburg PA
CBHW040928180526
45159CB00002BA/654